Angels

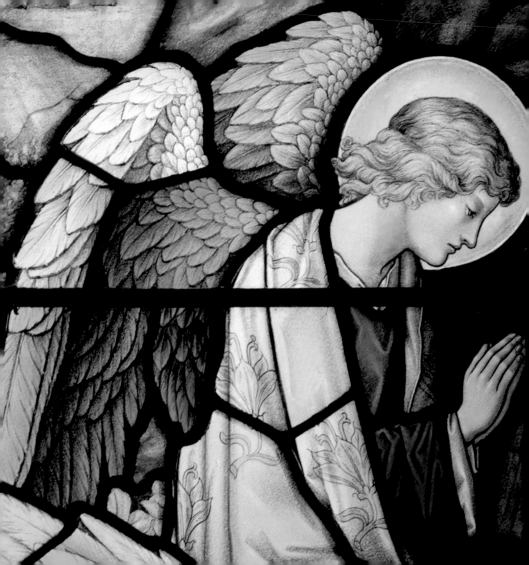

A Little Book

of

Angels

Text and Photography by

Mike Harding

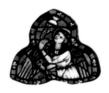

First published by Aurum Press Ltd
7 Greenland Street, London NW1 0ND
www.aurumpress.co.uk

Text and photography © 2008
Mike Harding

A catalogue record for this book is available
from the British Library.

ISBN 978 1 84513 305 4

Printed in China

Facing title page – St Mary, Woodplumpton, Lancashire
Title Page – Bury, Lancashire
Above – Wells Cathedral
Opposite – The Burrell Collection, Glasgow

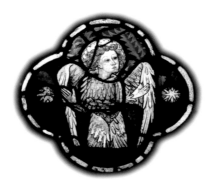

Up there with the smoke from a million chimney pots
They lived, their nighties smudged with specks of soot,
Weeping over your every sin, trotting
With you to school, inches above the ground, foot
Soldiers of the Lord.
Somehow yours sat beside you at your desk, unseen,
His cloud-soft wings closed like a prayer book,
Watching you mis-spell and stumble over words –
Your shadow, sewn to your feet,
Heavenly butterfly,
Guardian of your seven-year soul.

Poem by the author

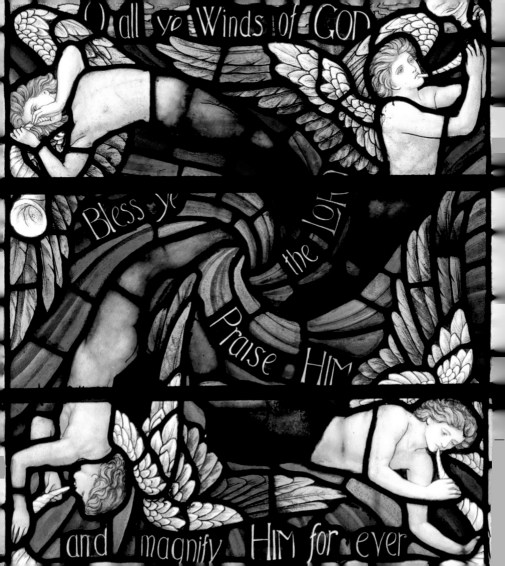

INTRODUCTION

Praise ye him, all his angels, praise ye him, all his hosts . . .
Praise the name of the Lord. For he spoke, and they were
made: he commanded, and they were created.

Psalm 148:2, 5

❖

Flying spirits that interceded between the gods and men, such as the winged Georgian cherub on this page from Burton Agnes, Yorkshire, and the horn-blowing angels, facing, from Casterton, Lancashire, have been a central tenet of Christian belief for 2,000 years.

Yet angels are much older than that. Some 3,000 years before Christ, the Sumerians, who lived in what is approximately present-day Iraq, believed that each of us has a ghost, a spirit that walks with us; we would perhaps call it a guardian angel. The Semitic tribes who conquered the region around 1900 BC borrowed the idea of angels from the Sumerians and divided the heavenly hosts into

hierarchies, a notion later taken up by Zoroastrianism, Judaism and Christianity (which devised its own orders: Cherubim, Seraphim, Powers, Dominions, Arch-angels, and so forth). Created by God as his helpers, angels were designed to live in joy with Him for ever. However, some of their kind fell from heaven through the arrogance of Lucifer, (the most beautiful of all angels and the Star of Morning) and became devils. The remainder, in their several orders, continued to serve God, in particular the great Archangels such as Michael and Gabriel who assumed more importance as special stewards of God – Michael in particular was responsible for fighting Satan and for holding the scales in which the sins of the dead were weighed on the Day Of Judgement.

We make our gods in the spirit of the time, and the medieval mind saw Heaven as a palace or city, structured much as a mirror-image of the King's court, with God as the almighty and eternal king sur-rounded by angelic chancellors and stewards. Michael, in his role as warrior angel, knight and champion of God, is therefore often shown as a knight in armour thrusting a spear down Lucifer's throat while trampling him underfoot. Though

there was no description of angels as half-man, half-bird in the scriptures, it became the custom in Christian iconography to depict them as winged creatures, perhaps drawing on carvings of the winged god of love, Eros, in classical Greek mythology.

Later, Mediaeval craftsmen, working on the great cathedrals and churches, covered their angels with feathers, as in the angel, facing, from Narborough, Norfolk. Victorian artists, heavily influenced by the Pre-Raphaelites, plucked off their angels' feathers and clad them in loose-fitting robes. Many of them became quite androgynous; some of them, in the best windows such as those by William Morris, or Shrigley and Hunt of Lancaster, are simply beautiful. As Britain became more martial, in the days of Empire, angels were often clad in medieval armour, and were shown fighting the good fight. The illustration on this page, from Norwich Cathedral, shows St Michael seeing off Satan who is in the shape of a slimy green dragon.

Over the centuries, artists making their angels in paint, stone and glass, from simple medieval glass panels to the majestic windows of the Victorians, have created through their inspired vision some of the world's greatest art.

Ancient and Modern

❖

Wirksworth, Derbyshire

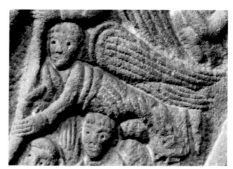

St Mary's, the parish church of Wirksworth, is one of my favourite English churches, a place of peace and a place of timeless tradition. It also contains some fine tombs and some wonderful Saxon carvings. The stone angel, above, can be found on a tomb lid that once covered the remains of an Anglo-Saxon priest, and is one of a group of angels helping the dead cleric to rise on Judgement Day. Close to the tomb lid is the angel opposite, more recent and part of a Victorian memorial window. I particularly like the naturalistic face on the angel, the delicacy of the brushwork on the luscious blue wings, the stitching of the garment and the gold of the angel's hair.

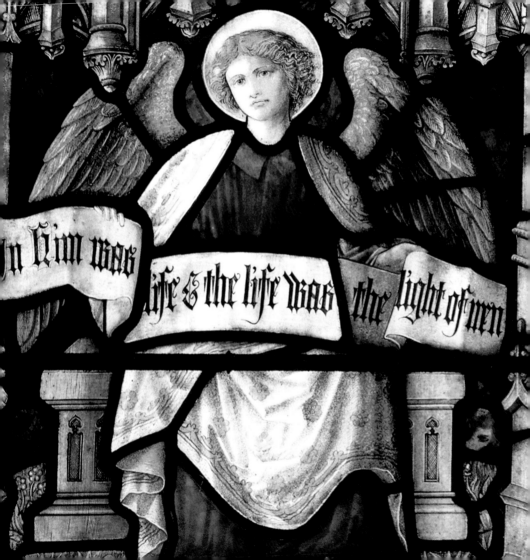

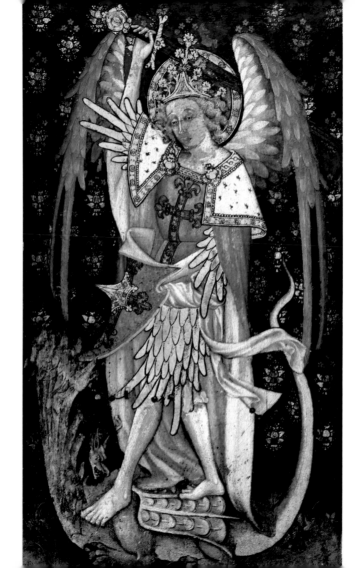

THE ORDERS OF ANGELS

Ranworth, Suffolk & Barton Turf, Norfolk

There are nine orders of angels: Seraphim, Cherubim, Thrones, Dominations, Virtues, Powers, Principalities, Archangels and Angels. Miraculously, a handful of rood screen panels somehow managed to survive the madness of the iconoclasts in East Anglia, and are wonderful examples of what we must have lost. The Archangel Michael, facing, comes from Ranworth. The angel on this page is a Throne,

and comes from Barton Turf; those on the pages following are also from Barton Turf. It is believed that the same artist worked in both churches, one theory being that he came from Barcelona. I like to think of that Catalan artist making his way from the parched lands of Catalonia into the damp fenlands of East Anglia and working quietly away with brush and paints in these little stone churches.

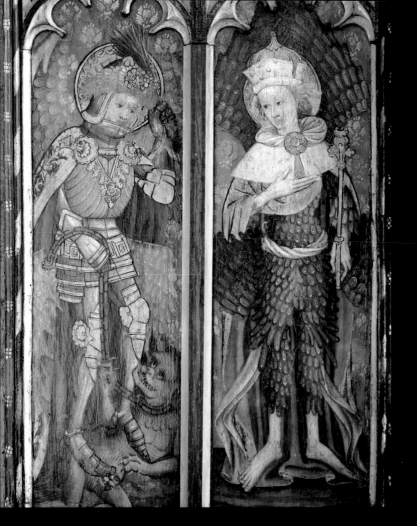

Powers and Virtues

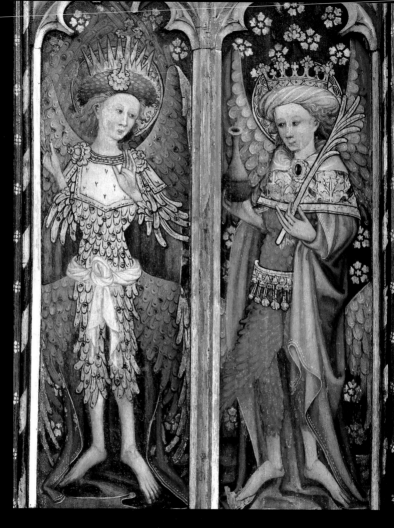

Cherubim and Principalities

Alabaster Angels

Ewelme, Gloucestershire & Burton Agnes, Yorkshire

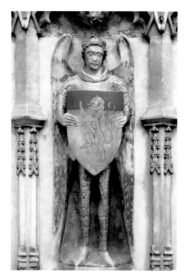

Alabaster is a mineral similar to marble in its ability to take a fine cut. The best beds of alabaster in the Middle Ages were to be found in Nottinghamshire, and alabaster from that county sailed down the Trent and was shipped over to Europe where some of the finest craftsmen turned it into plaques, reredos and statues. Alabaster was used in many English tombs and became, in effect, a very English art form. Many of the alabaster tombs had angels cut into the panels as companions to the dead. On this page, from Ewelme, an angel holds a shield on the tomb of Chaucer's granddaughter. The Burton Agnes angels, opposite, again carry an heraldic shield to proclaim the status and lineage of the deceased.

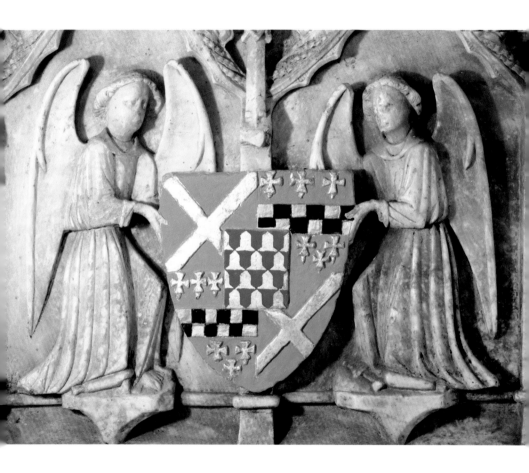

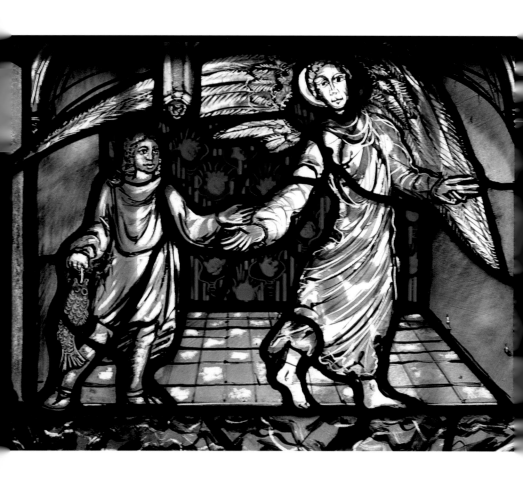

TOBIAS AND THE ANGEL

The legend of Tobias and the angel tells how young Tobias, sent by his blind father to collect a debt, finds himself accompanied by the archangel Raphael. The angel tells him that if he takes the heart, liver and gall from a fish, he will be able to cure his father's blindness, which he does when he returns home.

Tobias also takes his little dog with him on his journey, so he is often shown in carvings and paintings with an angel, a dog and a fish. The Flemish glass on this page comes from a fine window in the parish church at Preston; the glass panel on the facing page can be seen in the great Angel window of Southwell Minster. Tobias, here, has a fish but no dog.

19

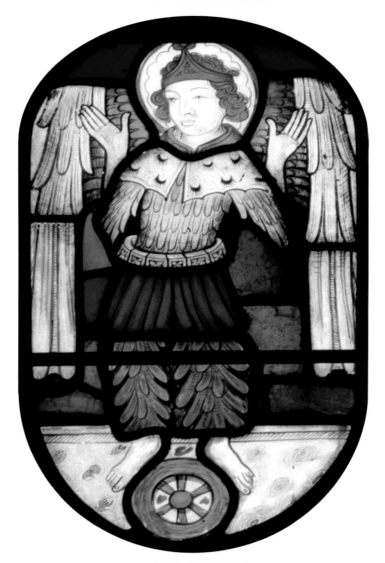

Wheels and Eyes

Martham, Norfolk

The earliest stained glass images of angels often show them covered with feathers. Some scholars maintain that this tradition comes from the medieval Mystery plays, when the actors playing angels wore tights and singlets with feathers stitched onto them. As well as feathers, angels had other distinguishing features. The Seraphim were often shown standing on wheels, as on the facing page, the wheels perhaps representing the wheel of Creation. Cherubim, like the one on this page, had eyes all over their wings and bodies, signifying great wisdom.

PARADISE GUIDES

❖

Kendal, Cumbria

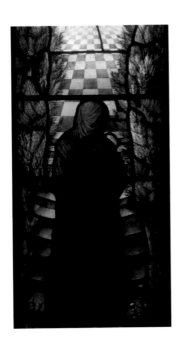

One of the main tasks of angels in the Christian tradition is that of guiding the souls of the dead towards their heavenly home. Angels weep at the loss of a single soul, so it is said, and rejoice as a soul attains paradise. The angels on the facing page come from the parish church in Kendal, and are part of a beautiful memorial window made by Shrigley and Hunt of Lancaster. With their lustrous wings, they wait for the soul (shown on this page) as it makes its way out of the darkling wood of this earthly life towards the eternal light of the paradise garden.

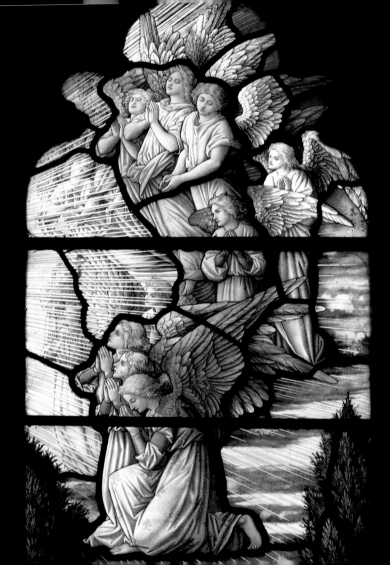

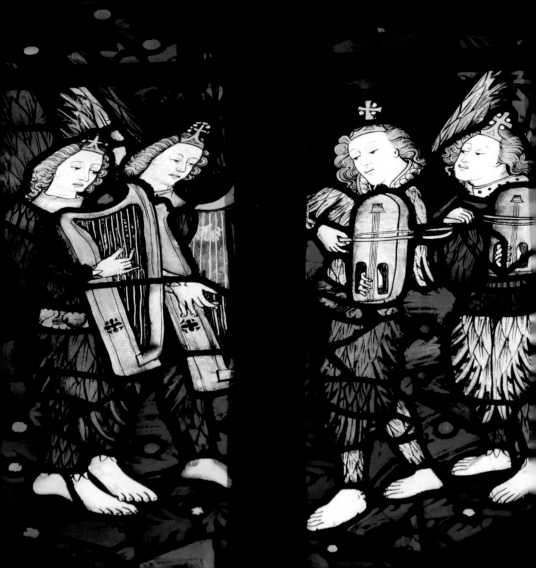

THE MUSIC OF THE SPHERES

❖

St Mary's, Warwick

The medieval world picture held that the order of the cosmos was maintained by a mystical music generated by the movement of the planets. Harmony and melody kept the Earth, Sun and Moon turning, kept the stars, and therefore the Zodiac, in their apportioned places, and maintained all things in their proper order. Little wonder then that we find so many angel musicians in medieval church art, as in the lovely glass work on these pages from St Mary's, Warwick. The angels opposite play harps and fiddles, while the angels, here, play a kind of early harpsichord.

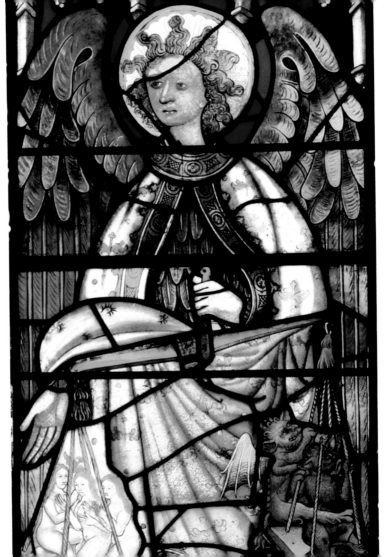

St Michael And The Scales

❖

Martham, Norfolk & Great Malvern, Worcestershire

According to tradition St Michael, the Archangel will be there on the Day Of Judgement holding the scales on which all our sins will be weighed against us. In the glass panel facing, from Martham, Michael's right hand may be pointing towards heaven, indicating that the souls have outweighed their sins. The enraged little devils in the other pan are trying to pull on the ropes and tilt the balance in their favour. In the medieval window on this page, from Great Malvern, a feathered Archangel Michael stands ready to separate the wheat from the chaff.

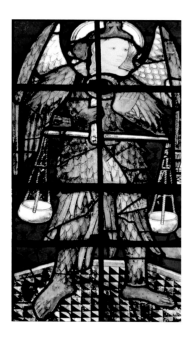

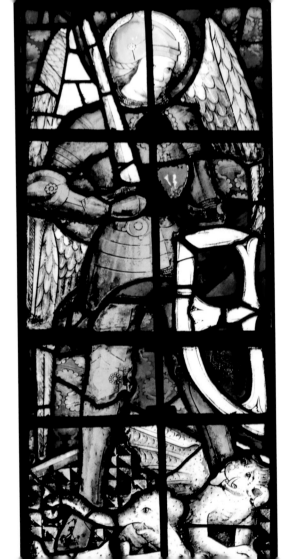

Saint Michael and Satan

Great Malvern, Worcestershire & St Mary's, Warwick

Shown with Satan at his feet and the scales of Judgment in his hands, St Michael on the page facing looks down into the body of the Priory Church of Great Malvern. The Devil beneath him is particularly interesting in that he has another face on his bum. Devils are often shown with extra faces, usually on their belly or genitalia, and the face on this bottom perhaps indicates the Church's attitude towards Sodomy. The lovely St Michael on this page, from Warwick, has his feet firmly planted on a brace of grumpy-looking little demons.

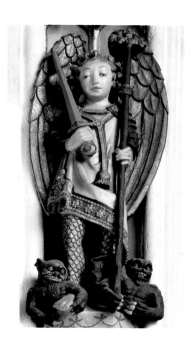

BURNE-JONES ANGELS

Ledbury, Herefordshire & Christ Church Cathedral, Oxford

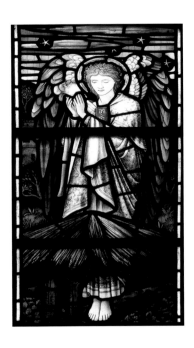

Edward Burne-Jones was one of the most influential artists of the Pre-Raphaelite Brotherhood, yet, apart from a few lessons from Rossetti, he was largely self-taught. A lifelong friend of William Morris, whose workshop made many Burne-Jones windows, he had a tremendous influence on church glassmakers during the later part of the nineteenth century. The angel on this page is part of a great collection of glass in Ledbury; the angel facing, part of a fine window in Christ Church. Both are typical Burne-Jones angels with their sensual lines and slightly androgynous faces.

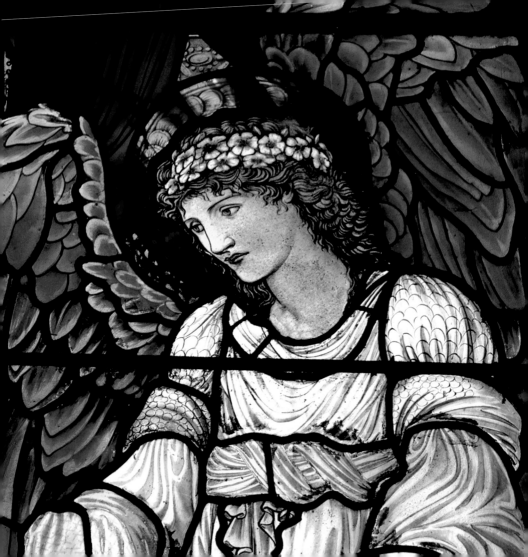

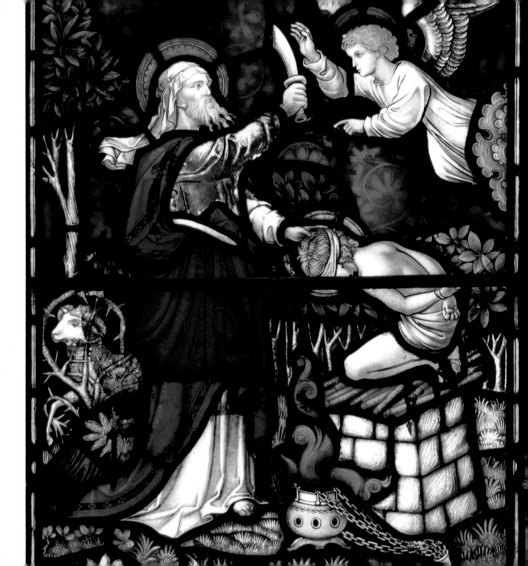

Angel Messengers

❖

Bury, Lancashire & Ledbury, Herefordshire

From the Annuciation to the Virgin Mary to the Day of Judgement, when they will blow the trumpets that signal the end of the world, angels have a job to do as go-betweens, linking God with the creatures of His creation. On this page, an angel in a Burne-Jones window in Ledbury brings news of the birth of the Saviour to the shepherds, while the angel on the facing page stills the hand of Abraham, who is about to sacrifice his son at the command of God. The pane is one of a fine series of Old Testament windows in one of the best Victorian churches in England.

Harry Clarke Angels

H arry Clarke (1889–1931) was one of the great glassmakers and artists of his time. Heavily influenced by Aubrey Beardsley and the Decadent Movement (his first published book illustrations were for Edgar Allan Poe's *Tales of Mystery and Imagination*), his art, at times, teeters on the very edge of the degenerate. What saves it, I feel, is his wonderful sense of balance and form: the sinuous lines and brilliant jewel colours which bring his work closer to the natural world than to the nightmare world of Beardsley.

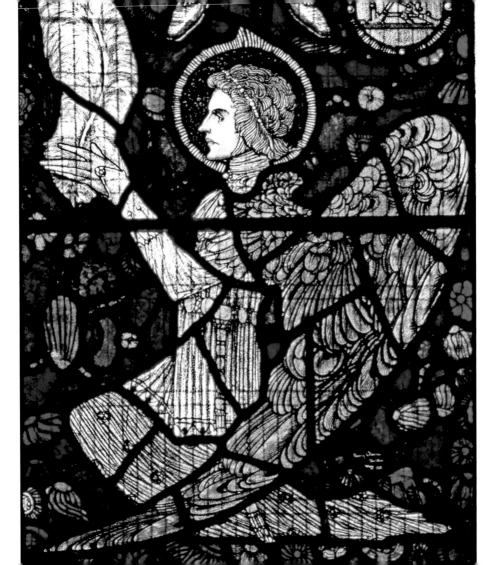

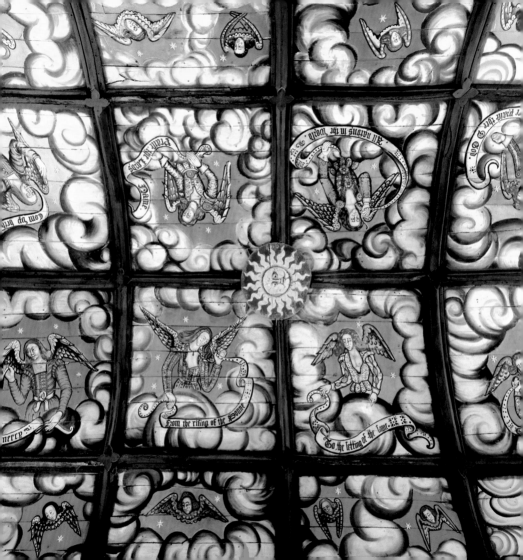

THE ANGEL CEILING

❖

Muchelney, Somerset

Muchelney is unique in having the finest and best preserved seventeenth-century angel ceiling in all of England. The barrel vault ceiling of the old church of SS Peter and Paul swarms with angels. The main panels are filled with single angels framed by cloud. They wear Elizabethan dress and some of their tunics are open almost down to the waist. That this lovely ceiling survived may be partly

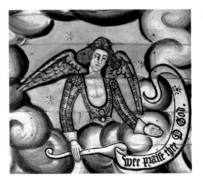

due to the fact that Muchelney stands on an island of higher ground in the midst of the Somerset Levels. Even today, the Levels can flood and cause the village to become a real island once again. In the seventeenth century the area would not have been drained and, like East Anglia, was fairly isolated from the rest of the country, and not so easy for the Christian Taliban to get to.

Henry Holiday Angels

❖

Casterton, Lancashire & Rydal, Cumbria

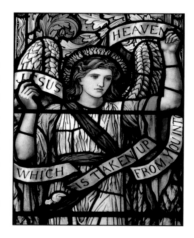

Henry Holiday (1839–1927), whose stained glass appears in churches all over England and the USA, was a friend of the influential writer and art critic, John Ruskin. It was at Ruskin's house near Coniston that he met the artist Burne-Jones, who was to have a great influence on Holiday's work. The panel facing can be found in St Mary's, Rydal, a small unadorned church where the Wordsworth family worshipped for a quarter of a century; their pew is still there. On this page is a small panel from a wonderful window in Casterton church. A larger panel from the same window appears on p. 6 of this book.

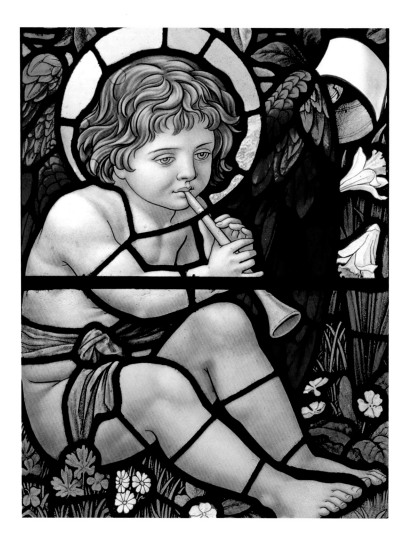

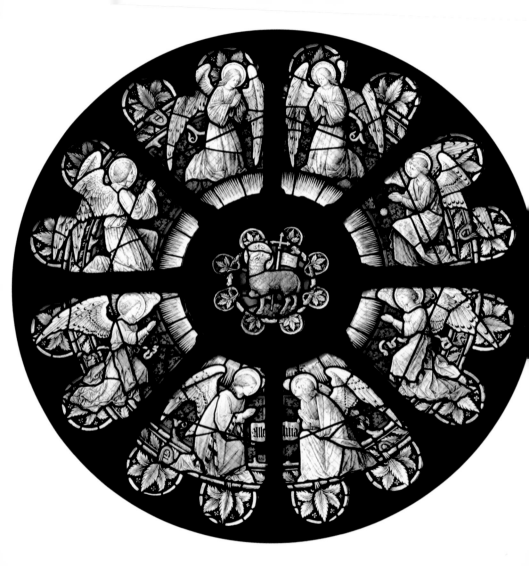

Angel Wheels

❖

Scotforth, Lancaster & Garstang, Lancashire

The beautiful rose window opposite can be found in a most interesting church, St Peter's, Scotforth, on the outskirts of Lancaster. A basilica-like building, it was the work of a Lancaster architect, Edmund Sharpe (1809–1877). Sharpe was fond of terracotta, so much so that he became famous for what were known as his 'pot churches'. At St Peter's even the main capitals are made of stone-coloured terracotta. I was particularly taken by the rose window opposite, with its glorious collection of angels, high in the west wall. On this page, as though he is emerging from a wheel, a warrior angel strides out of the window at St Helen's, Garstang.

Jacob And The Angels

❖

Ely, Cambridgeshire & Bury, Lancashire

Jacob fell asleep on the ground with a stone for a pillow, 'And he dreamed that there was a ladder set up on the earth, and the top of it reached to heaven; and behold, the angels of God were ascending and descending on it.' (Genesis 28:11-19) On this page, from Ely's lovely cathedral, angels watch over the sleeping Jacob as he dreams of the ladder that will reach all the way up to paradise. The Parish Church of St Mary, Bury, is a wonderful Arts and Crafts church with some fine stained glass including the panel on the facing page, showing Jacob asleep, shepherd's crook in hand.

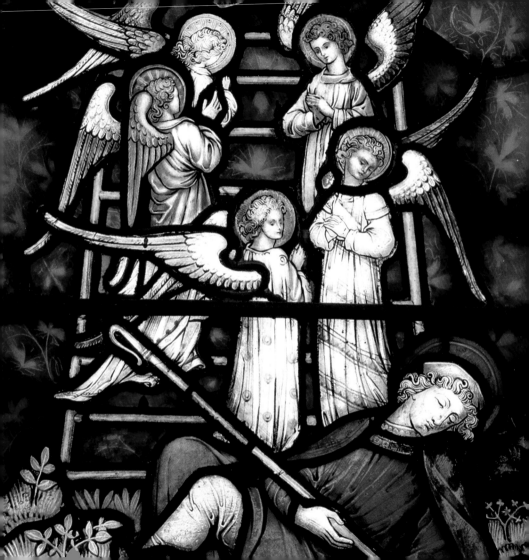

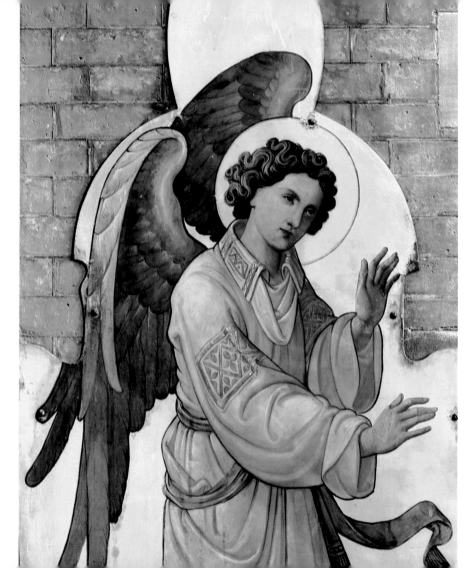

Byzantine Angels

❖

Bury, Lancashire

Almost as though they have been lifted from a Byzantine church, the two angels here, with their flat gold background, seem to be a pair of Victorian panels that at some time were cut to fit around an architrave or moulding. The workmanship is fine and, though they are consigned to a wall in a side chapel at St Mary's Parish Church, they are obviously well cared for. Pevsner, that great writer on church architecture, omits to mention them.

THE SCULTHORPE ANGELS

Sculthorpe, Norfolk

John Betjeman, in his introduction to his book on English churches, speaks of the certainty that was felt by the laity during the reign of Victoria: the squire in his hall, the rector in his vicarage, God smiling benignly on England and her Empire. It was this kind of faith that produced these wonderful windows in Sculthorpe, commissioned by Willoughby and Emily Jones. This memorial window, part of a group of extremely fine Victorian windows, was made to celebrate the lives of their son and daughter, both of whom died abroad, possibly in service of that very Empire. Though we now live in a post-imperial world I can't help but wonder at the many hundreds of such small, English country churches that must still contain similar memorials to the sons and daughters who went overseas, never to return...

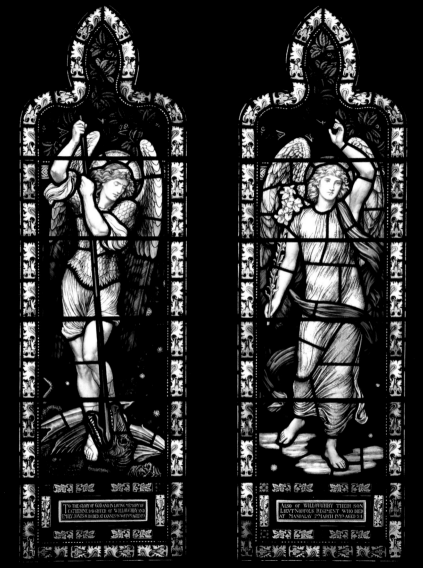

TO THE GLORY OF GOD AND IN LOVING MEMORY OF
CATHERINE DAUGHTER OF WILLOUGHBY AND
EMILY JONES WHO DIED AT CANNES 16th NOV 1879 AGED 19

ALSO OF WILLOUGHBY THEIR SON
LIEVT NORFOLK REGIMENT WHO DIED
AT MANDALAY 5th MARCH 1889 AGED 24

OPUS SECTILE ANGELS

Shrewsbury, Shropshire & Hucknall, Nottinghamshire

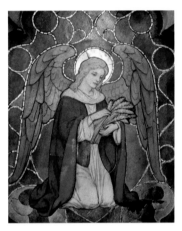

Mosaics of any kind are rarer in the churches of these islands than on the continent; we have nothing, for example, to compare with the great Byzantine dome of St Mark's, Venice. The Victorians did something to remedy this, and artists, influenced by the work of the Pre-Raphelite Brotherhood, produced some quite beautiful work including the opus sectile mosaic panel, on the facing page, from Hucknall, made by James Powell (circa 1897). Opus sectile mosaics employed large pieces of glass and ceramic instead of thousands of small pieces of *tesserae*. The Powell workshop in London was noted for its high quality panels. The panel on this page, also from the Powell workshop, is part of a beautiful reredos in St Mary's, Shrewsbury.

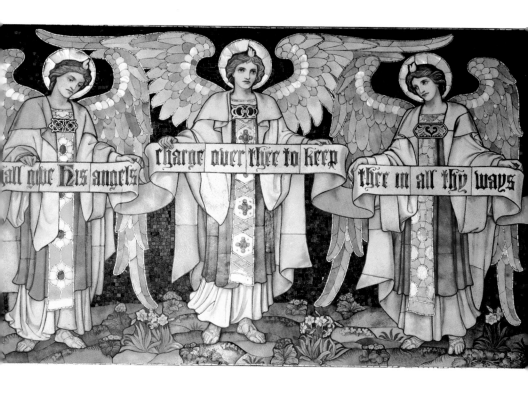

all give His angels charge over thee to keep thee in all thy ways

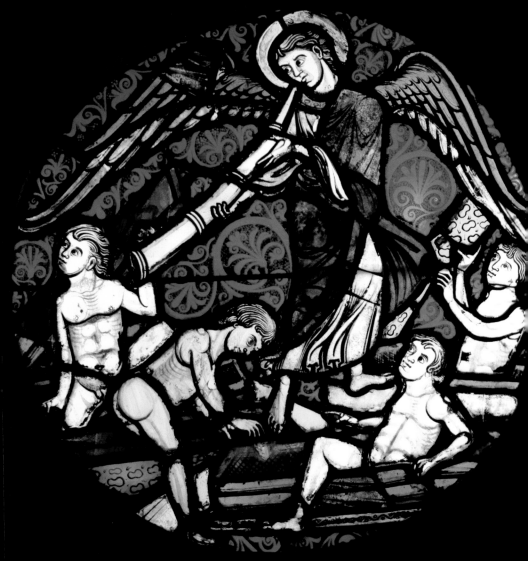

Angels in Glass and Stone

Musée Cluny, Paris & Kilpeck, Herefordshire

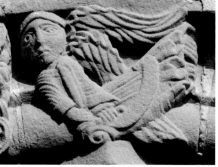

On the last day the horn will sound and the dead will rise from their graves to be judged by the Almighty. The wonderful roundel of medieval glass on the page opposite is a magnificent example of the glass painter's art and is just one example of many such gems in Paris's fine museum of medieval art. The flying stone angel on this page can be found high on the exterior wall of the church of St Mary, Kilpeck. The church is probably the greatest Romanesque building in these islands. It is covered in carvings, grotesques, animals and Green Men swarm all over it. Cut with infinite craft into the red sandstone, it is one of the world's wonders.

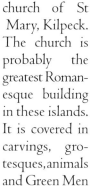

THE ANGELS OF SOUTHWELL

Southwell Minster, Nottinghamshire

Known as the Angel Window, Southwell's West Window is a modern reworking of a medieval theme. Using the same tints and tones that would have been found in the original window – destroyed by fundamentalist zealots – Patrick Reyntiens designed a joyous window that was then created by master glazier Keith Barley of York. When the

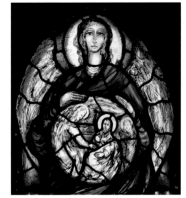

late sun falls on this window it is a truly glorious sight. On the page facing are two of the seven lower panels showing the days of Creation. On this page, another angel is part of a group of interesting modern windows in the passage connecting Southwell's wonderful Chapter House with the body of the church.

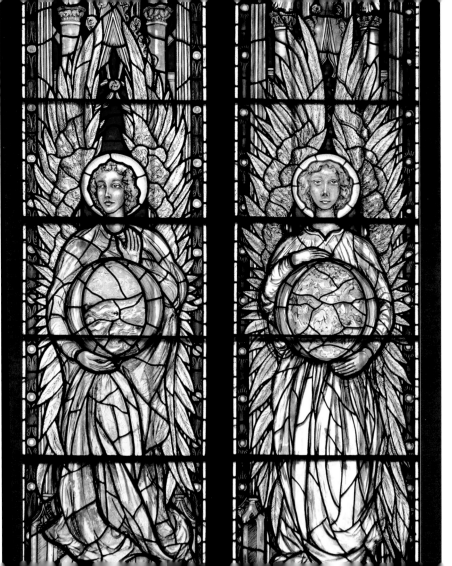

THE MALPAS ANGELS

❖

Malpas, Cheshire

On the afternoon I went to St Oswald's, Malpas, the church was open (it is only open only two days a week for visitors) and two of the parish ladies were acting as unofficial guides. They told me that

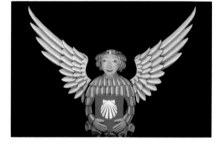

every one of the lovely mediaeval angels in the roof (one for every beam) had been repainted by the vicar's wife. She's done a grand job. The angel here holds a shield showing a scallop shell, the symbol of St Iago de Compostela, and thus signifying pilgrimage. The angel facing holds a chalice containing a serpent or dragon, the symbol of St John the Evangelist.

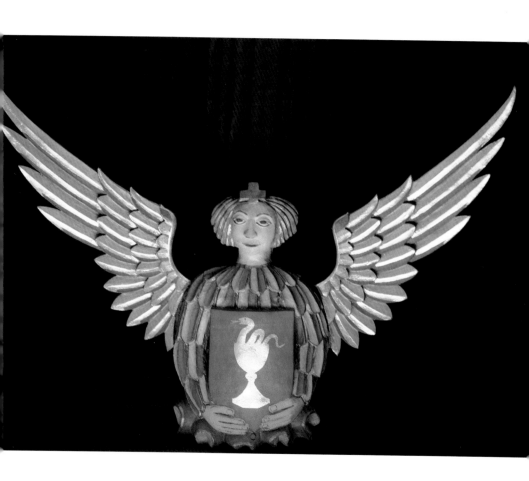

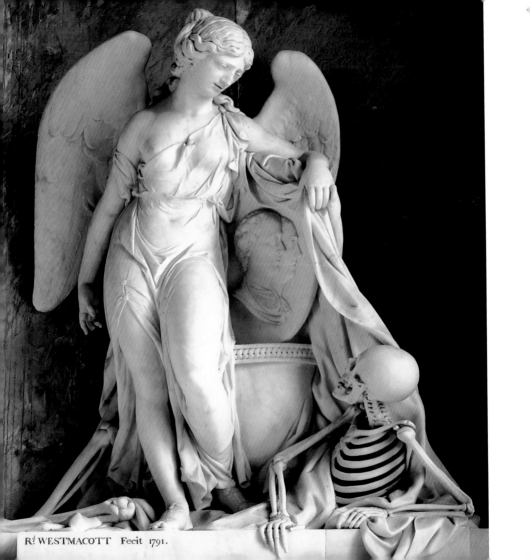

R.ᵈ WESTMACOTT Fecit 1791.

DEATH AND THE ANGEL

❖

Sherborne, Gloucestershire & Ludlow, Shropshire

Standing as though in victory, the angel opposite from St Bartholemew's, Sherborne, carved by Richard Westmacott in 1791, is an impressive piece of work. The angel is leaning on a cameo of James Lennox Dutton and his wife, and is said to be trampling Death down in triumph. The skeleton seems horribly real and, though it looks as if the black lines on the rib cage are painted on, the chest is in fact

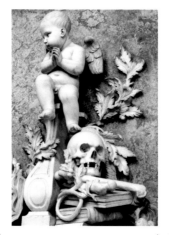

hollow — an amazing piece of work. On this page, from Ludlow, a cherub rides high above a memorial to Theophilus Sawley, the angel's foot on the skull symbolising the eventual triumph of life over death. *Putti*, as such fat little cherubs are called, represented innocence. In some carvings little more than a head was shown.

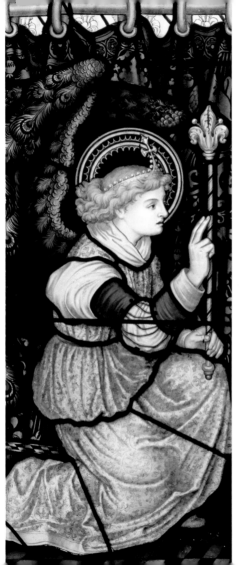
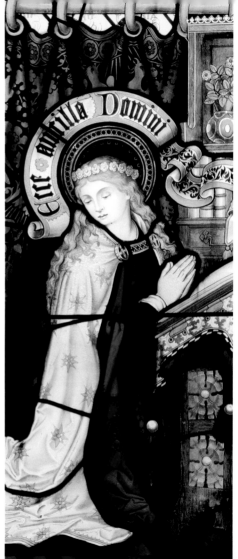

The Archangel Gabriel

Much Marcle, Herefordshire & Newark, Nottinghamshire

As Mary is all alone, an angel of the Lord appears to her to annnounce that she is to be the mother of the Messiah, the saviour of the world. Tradition says that the angel was the archangel Gabriel and this central tenet of the Christian faith has been celebrated by artists for hundreds of years. Charles Kempe, one of the finest Victorian glassmakers, produced the panel facing. Gabriel on this page comes from a fine medieval window in the church of St Mary Magdalene, Newark.

CREATION ANGELS

❖

Chipping Norton, Oxfordshire

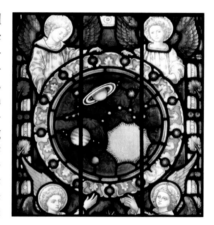

Clayton and Bell, the great nineteenth-century Birmingham glassmakers, are credited with the creation windows at Chipping Norton. The angels hold roundels showing the stages of the world's making: shown here are the making of the firmament, and the creation of stars and planets.

The creation of life on earth is shown on the pages following. The window is a glorious celebration of Life, and the glassmakers' art and imagination flow organically from one subject to the next. Note the purple elephants and the pink camel and magenta giraffe.

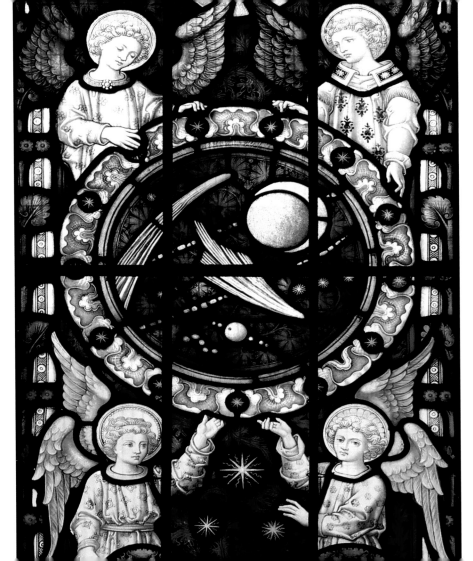

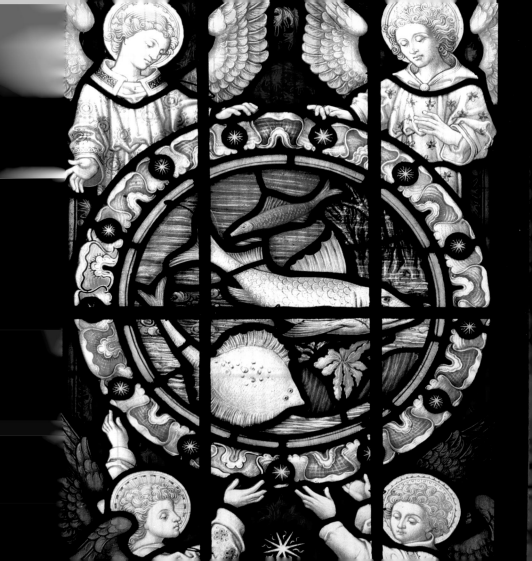

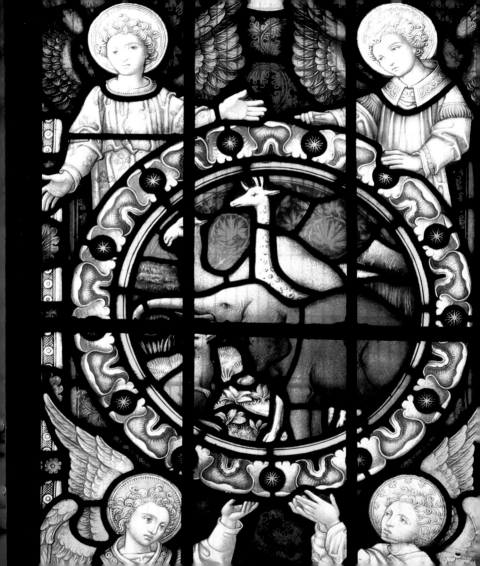

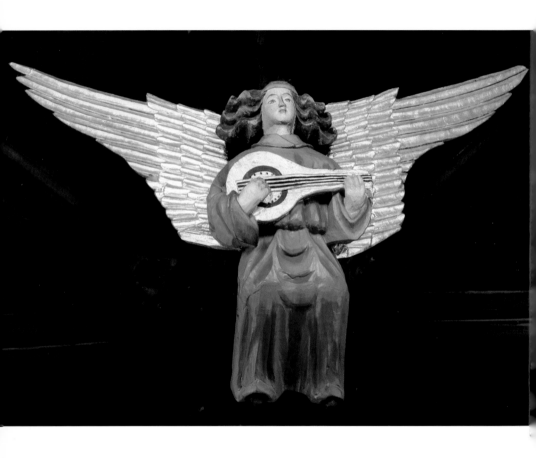

ANGEL CORBELS

❖

Wrexham, Clwyd, Wales

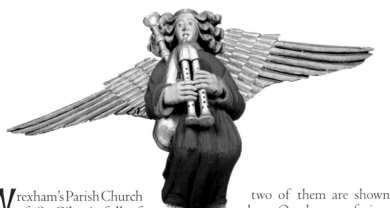

Wrexham's Parish Church of St Giles is full of treasures, from medieval stone corbels to some fine panels of lovely stained glass. High in the ceiling, up amongst the roof timbers, is a set of musical angels; two of them are shown here. On the page facing, the angel is playing a lute of some kind. On this page a slightly lopsided angel plays a set of bagpipes with two chanters.

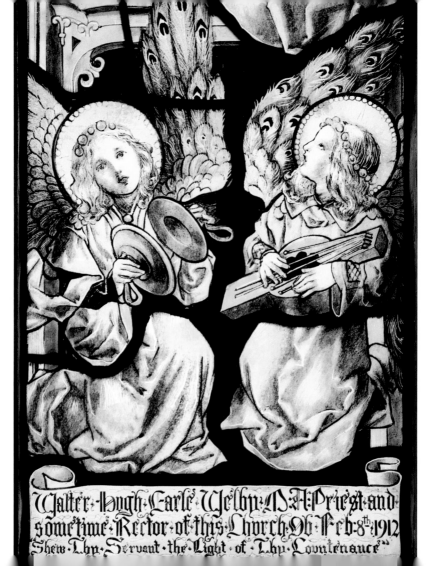

Walter · Hugh · Earle · Welby · M.A. Priest · and
sometime · Rector · of · this · Church · Ob · Feb · 8th · 1912
"Shew · Thy · Servant · the · Light · of · Thy · Countenance"

CHILD ANGELS

❖

Harston, Lincolnshire

I happened on these windows purely by chance. I had gone to Harston to photograph the Green Men there and found these charming little windows, installed to commemorate the Rev. Walter Hugh Earle Welby, M.A., who had the living of Harston. The Welbys were a very old local family. I looked at the windows for a long time – wondering where I had seen similar faces – then remembered that it was in old Victorian children's books I had come across as a child. The angels here come from another time, a time of imagined and longed-for innocence.

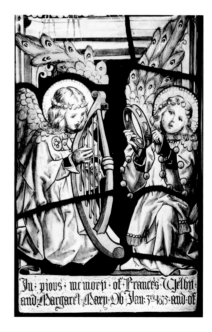

My thanks go the the Deans and Chapters of all the cathedrals whose treasures are featured in this book, and likewise to all the vicars, vergers and enthusiastic helpers who gave me so much assitance. Draughty churches and chapels were opened up to me, and many people, who obviously love their churches, went to great lengths to light my way in the darkness. Special thanks go to the Burrell Collection, Glasgow, a treasure maintained by and for the people of that city, for permission to use the medieval angel on p. 7 and many, many thanks go to my fellow church-crawlers who pointed me the way to so many treasures. I offer this book as my thanks to all the above and to the men and women who created such great art to the glory of their God.

The cameras used were Nikons throughout: an F90 in the good old days of film and, more recently, a Nikon D2X. I used a variety of lenses, from ultra wide angle to a 600mm telephoto. For difficult lighting conditions I used a small hand-held video light.

The angel on this page comes from Wells Cathedral, Somerset; the angel opposite from a Millennium window at Adderbury, Gloucestershire